Muscled bodies

Michel Lauricella

MORPHO

anatomy for artists

rockynook

Morpho: Muscled Bodies
Michel Lauricella

Editor: Maggie Yates
Project manager: Lisa Brazieal
Marketing coordinator: Mercedes Murray
Graphic design and layout: monsieurgerard.com
Layout production: Hespenheide Design

ISBN: 978-1-68198-759-0
1st Edition (2nd printing, April 2022)

Original French title: Morpho XXL corps bodybuildés
© 2020 Éditions Eyrolles, Paris, France
Translation Copyright © 2021 Rocky Nook, Inc.
All illustrations are by the author.

Rocky Nook, Inc.
1010 B Street, Suite 350
San Rafael, CA 94901
USA
www.rockynook.com

Distributed in the UK and Europe by Publishers Group UK
Distributed in the U.S. and all other territories by Ingram Publisher Services

Library of Congress Control Number: 2020949314

This book is printed on acid-free paper.
Printed in China

Publisher's note: This book features an "exposed" binding style. This is intentional, as it is designed to help the book lay flat as you draw.

table of contents

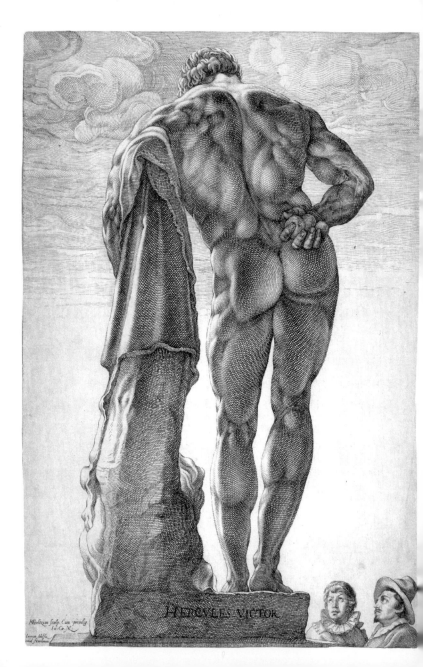

HERCVLES VICTOR

foreword

The aesthetics of muscular bodies have been strongly anchored in our culture since ancient times. The physiques of the heroes of Greco-Roman mythology can be found today in an exaggerated form in the representations of superheroes and superheroines that we find in comics and graphic novels, animated movies, live-action movies, and video games. Bodybuilding athletes sculpt their bodies like a work of art, and here we offer a repertoire of ideal forms to be used in this type of representation.

In recent decades, the canonical shapes of bodybuilding have rapidly evolved, leading bodies into an incredible muscular one-upmanship. During competitions, athletes are separated by sex, and then into categories of weight and age. Some of the poses that you will find in these pages are required by the discipline. Most of the drawings presented here are based on photographs of champions in the various categories, which value an extraordinary development of muscle mass, thus deviating from the "classical" and more natural ideals. The path I have taken here is to choose the most excessively developed shapes in order to better meet the needs of drawing.

Superheroes and superheroines in every genre are generally represented as fighting against characters who are every bit as muscled as they are!

In the preparation for bodybuilding competitions, we can distinguish a phase of muscle mass gain (through physical training and caloric intake), followed by a cutting phase (eliminating as much fat as possible). At that point the skin looks as though it is glued to the muscles, and the athletes take on the appearance of a muscled écorché figure. The bodies become veritable anatomical treatises, highly readable. The muscles stand out clearly from each other, their fibers emerge, and the direction they point in shows us their function. On the other hand, it is true that the skeleton is less discernible and that many of the bone landmarks that we are used to drawing in relief are now found at the bottom of depressions, dimples, or grooves. The absence of fat also erases differences between individuals and between the sexes. Many of the drawings presented in this volume were based on female athletes: because their bodies have been broken down into their component parts for our purposes here, however, that will not always be obvious.

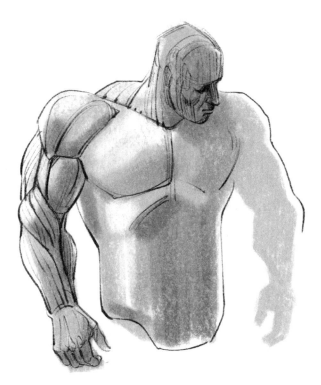

introduction

I reproduce, in this introduction, the presentation of the various kinds of muscles. Over the pages of this book, you'll see some of the drawings and diagrams that I created for the book *Joint Forms and Muscular Functions* in this series, which will help you to understand the action of the various muscles that are presented here as almost invariably hypertrophied and in the midst of exertion, as they appear in training or at competitions. The numbers refer to a summary table, under the flap at the very end of the book. This numbering also corresponds to the one that is used for the title mentioned above so that you can refer to it as needed (that book also details the insertions and muscle functions). I have also slipped in, at the end of this introduction, some of the drawings of veins from the book *Hands and Feet*. These illustrative plates are highly relevant here because the efforts imposed by the discipline of bodybuilding also strongly develop the venous network.

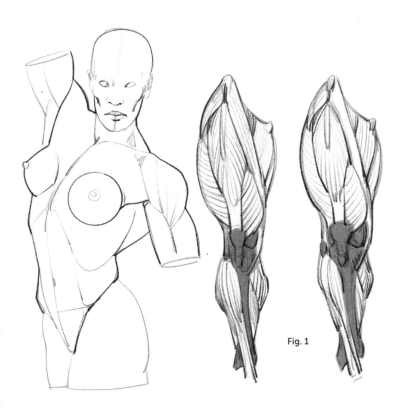

Fig. 1

In increasing muscle volume, you will also be tempted to thicken the skeletal frame. But the skeleton cannot keep up with the spectacular developments of the musculature in the same proportions, and your muscular characters can very well continue to maintain delicate bones and joints, or even to gain them by contrast (Fig. 1). The body shapes that have been adapted and developed for the sake of a variety of athletic challenges are the proof of that. Of course, bodies that are endowed with a strong skeletal framework will be very well adapted to this muscular load, as well as to the sustained work required for this kind of gain in mass, especially for movements that go in the direction of weightlifting.

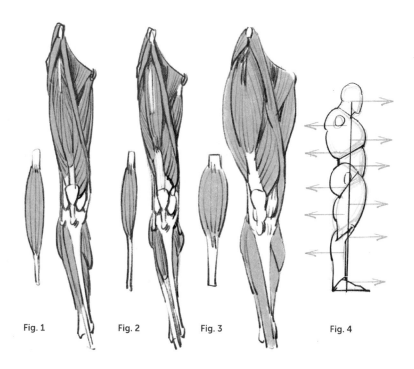

Fig. 1 Fig. 2 Fig. 3 Fig. 4

Types of muscles

The proportion of tendon fibers to muscle fibers can vary from one muscle to the next, and for the same muscle from one person to the next. A short muscle with a long tendon will contract more quickly, but a long muscle will have greater flexibility and range. Thus, simply by playing with this one parameter, you can make a character's silhouette either more flexible or tenser (Figs. 1 and 2). What makes one muscle more powerful than another is its thickness, along with the number of fibers involved in a given insertion (Fig. 3).

Increasing muscle volumes will also reinforce curves (difference in contours), the dynamic balance of the various segments (convexities, Fig. 4), and the depressions at the sites of muscle attachments (concavities, Fig. 5).

These fibers are connected together in bundles called fasciae. Several fasciae grouped together around one tendon form a biceps (2 fasciae), triceps (3 fasciae, Figs. 6 and 7), or a quadriceps (4 fasciae), which gives the entire combination that much more strength. Tendons can sheathe a muscle and/or slip inside another muscle.

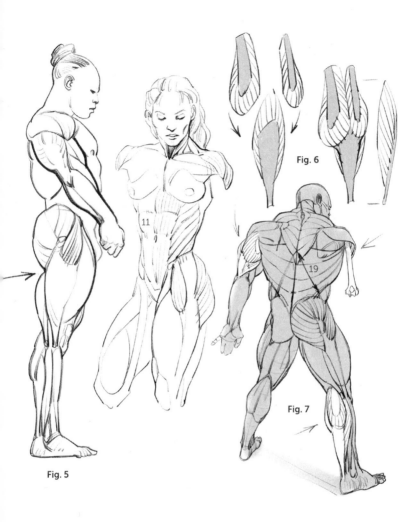

Fig. 6

Fig. 5

Fig. 7

A pinnate (or feather-shaped) structure (Fig. 6) results in a muscle with a large number of short fibers arranged in tiers on the tendon. Superficial muscles can form layers connected to tendon plates (for example the latissimus dorsi, 19). Others are broken up by tendinous intersections, which tends to reduce their elasticity (the rectus abdominis, commonly called abs, 11).

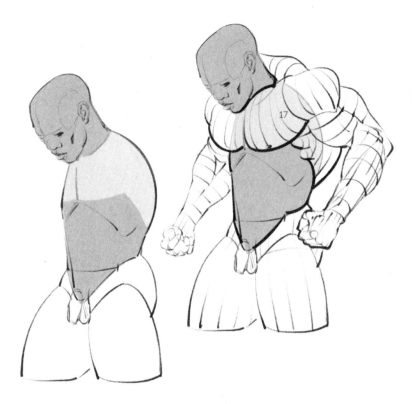

This book is divided into chapters corresponding to the various regions of the body. Here again, I have chosen, in the section on the torso, only to deal with the musculature that connects the rib cage to the pelvis. From a mechanical standpoint, we can count the pectorals (17), the trapezoids (14), and the latissimus dorsi (19), which predominantly participate in all of the movements of arm lifting and lowering, among the muscles of the upper limb. We will see that they are not the only ones

that connect the limb to the torso by way of the shoulder blades and collarbones, which can therefore, by the same reasoning process, be considered as the first bones of the upper limb. When the musculature of the upper limb is hyperdeveloped, it thus transforms the silhouette of the torso. This musculature fills in the front and sides of the top of the rib cage and extends, in the back, from the skull to the pelvis, thus covering the entire back.

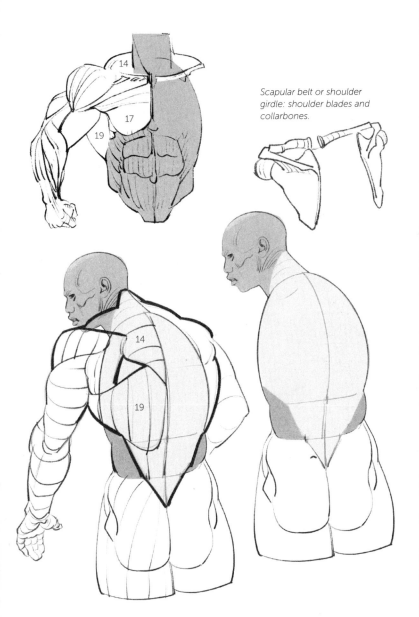

Scapular belt or shoulder girdle: shoulder blades and collarbones.

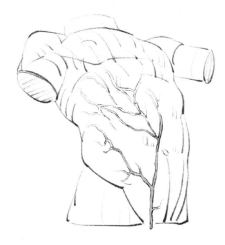

The veins

The veins form a complex and seemingly random network. The "canonical" arrangement described here will not be able to coincide exactly with reality: at the very most, we can trace the path of the major veins. Their size is variable, dilating with the influx of blood and becoming larger with regular and sustained exertion. They can take on a knotted appearance, folding back on themselves, and they are often in communication with each other.

In the region of the head and the neck, we can see the temporal vein, which cuts across the path of the sternocleidomastoid to join the external jugular. Starting at the corner of the jaw, it slides into the depression behind the collarbone.

The integument of the abdomen (see Paul Richer's book, Artistic Anatomy) covers the torso, starting at the lower abdomen, cutting across the fold of the groin, and then joining the long saphenous vein.

The veins of the upper limb extend from the fingertips and trace a series of arches on the first phalanges, under the heads of the metacarpals. They then meet up again on the back of the hand, where they connect to form an inverted arch. They give rise to two branches that then frame the limb along its entire length, reconnecting halfway through at the hollow of the elbow; then, on the forearm, the radial vein on the side of the radius (1) and the cubital vein on the side of the ulna (2) continue their ascent, changing their names on either side of the biceps. On the inside, the basilic vein disappears into the armpit. On the outside, the cephalic vein slips between the deltoid and the pectoral to disappear into a depression underneath the collarbone.

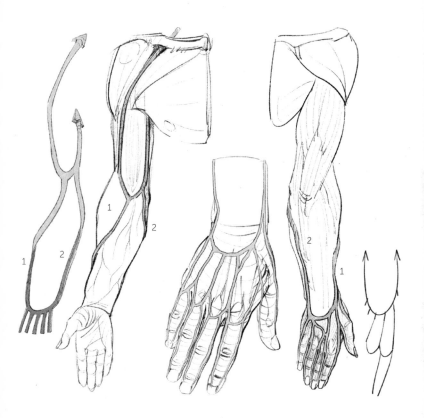

At the beginning, there are a large number of veins and they follow random pathways; as they climb toward the shoulder, their numbers decrease and they become larger and therefore simpler in their appearance. The "classical" version traces a capital M on the inside of the elbow (Fig. 1, next page). At that point, one can imagine two more veins connecting to the previous ones, one of them (3, Fig. 2, next page) coming from the back of the forearm and the other (4) from the front of it.

Beginning at the back of the fingers and hand, the veins curl around the sides of the forearm to connect at the front of the elbow.

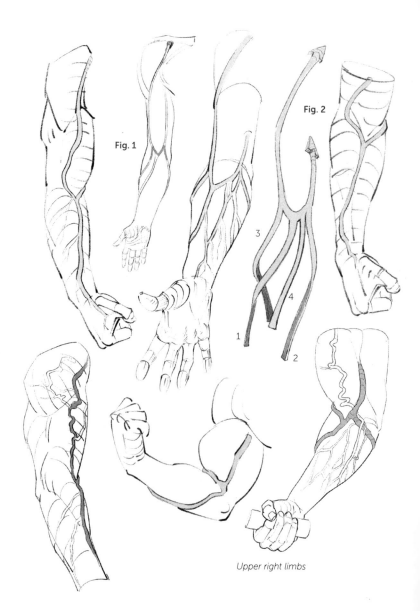

Fig. 1

Fig. 2

3

4

1

2

Upper right limbs

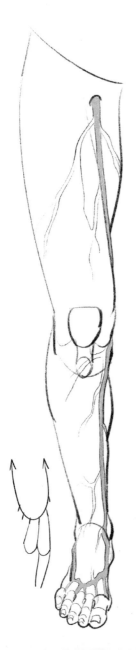

The lower limb is arranged somewhat similarly. The veins start at the back of the toes and the foot, create an arch, and converge in two main trunks. The long saphenous vein goes up to the level of the hip joint, following the path of the sartorius along the thigh, while the short saphenous vein stops at the back of the knee.

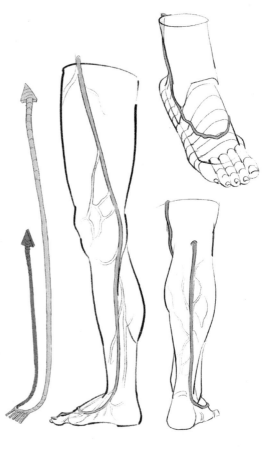

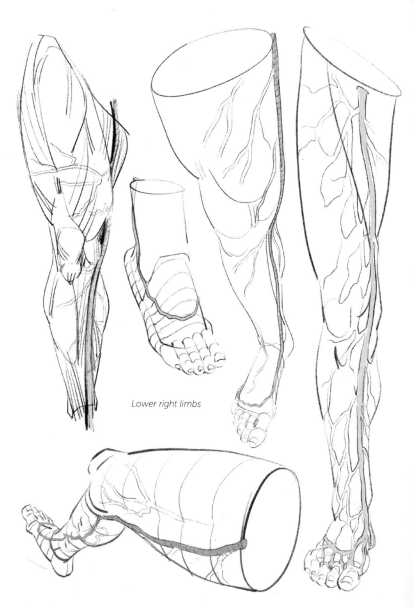

Lower right limbs

plates

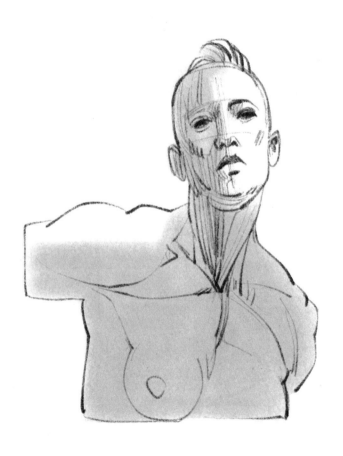

head & neck

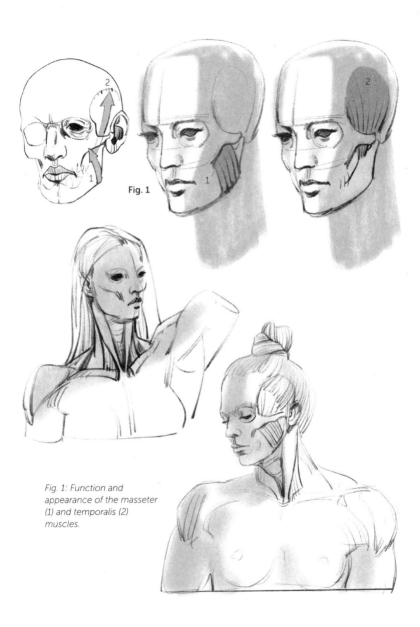

Fig. 1

Fig. 1: Function and appearance of the masseter (1) and temporalis (2) muscles.

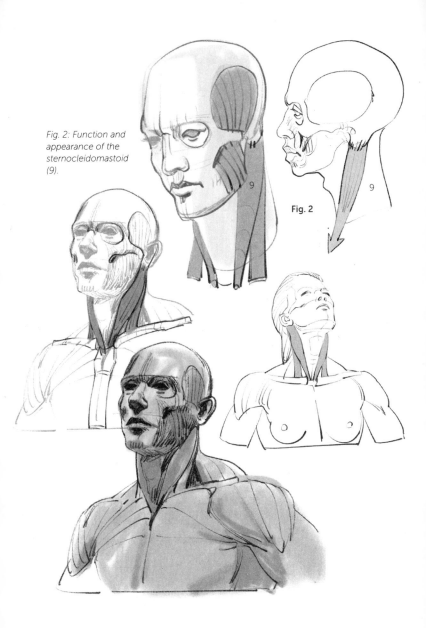

Fig. 2: Function and appearance of the sternocleidomastoid (9).

9

Fig. 2

9

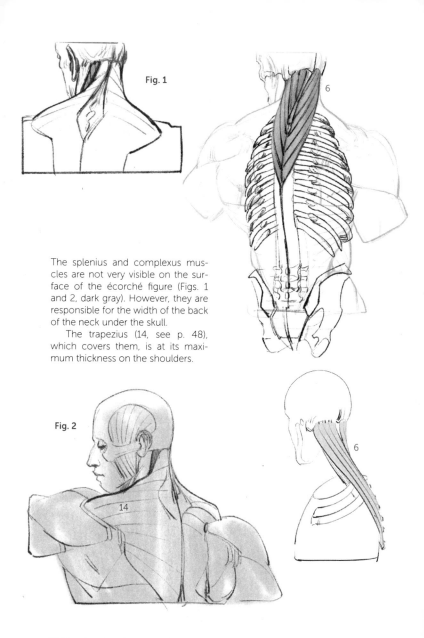

Fig. 1

6

The splenius and complexus muscles are not very visible on the surface of the écorché figure (Figs. 1 and 2, dark gray). However, they are responsible for the width of the back of the neck under the skull.

The trapezius (14, see p. 48), which covers them, is at its maximum thickness on the shoulders.

Fig. 2

14

6

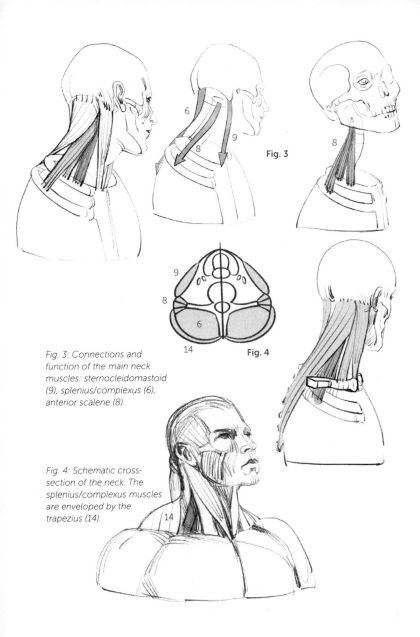

Fig. 3

Fig. 4

Fig. 3: Connections and
function of the main neck
muscles: sternocleidomastoid
(9), splenius/complexus (6),
anterior scalene (8).

Fig. 4: Schematic cross-
section of the neck. The
splenius/complexus muscles
are enveloped by the
trapezius (14).

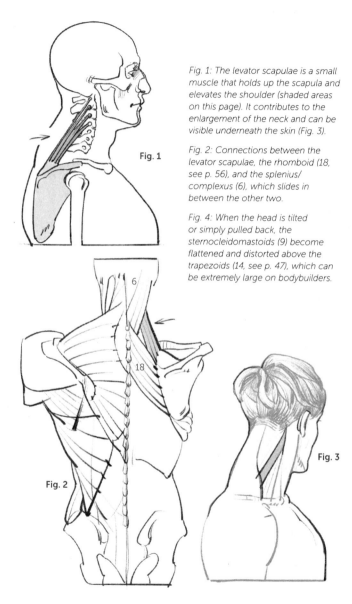

Fig. 1: The levator scapulae is a small muscle that holds up the scapula and elevates the shoulder (shaded areas on this page). It contributes to the enlargement of the neck and can be visible underneath the skin (Fig. 3).

Fig. 2: Connections between the levator scapulae, the rhomboid (18, see p. 56), and the splenius/complexus (6), which slides in between the other two.

Fig. 4: When the head is tilted or simply pulled back, the sternocleidomastoids (9) become flattened and distorted above the trapezoids (14, see p. 47), which can be extremely large on bodybuilders.

Fig. 1

6

18

Fig. 2

Fig. 3

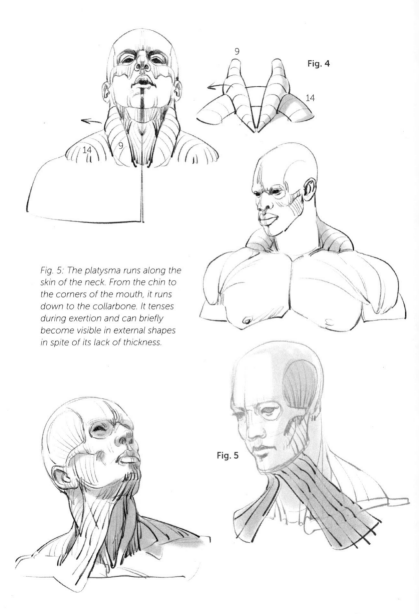

Fig. 4

9

14

Fig. 5: The platysma runs along the skin of the neck. From the chin to the corners of the mouth, it runs down to the collarbone. It tenses during exertion and can briefly become visible in external shapes in spite of its lack of thickness.

Fig. 5

torso

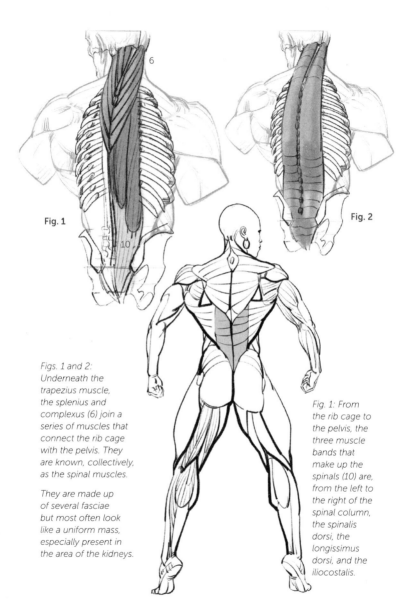

6

Fig. 1

10

Fig. 2

Figs. 1 and 2:
Underneath the
trapezius muscle,
the splenius and
complexus (6) join a
series of muscles that
connect the rib cage
with the pelvis. They
are known, collectively,
as the spinal muscles.

They are made up
of several fasciae
but most often look
like a uniform mass,
especially present in
the area of the kidneys.

Fig. 1: From
the rib cage to
the pelvis, the
three muscle
bands that
make up the
spinals (10) are,
from the left to
the right of the
spinal column,
the spinalis
dorsi, the
longissimus
dorsi, and the
iliocostalis.

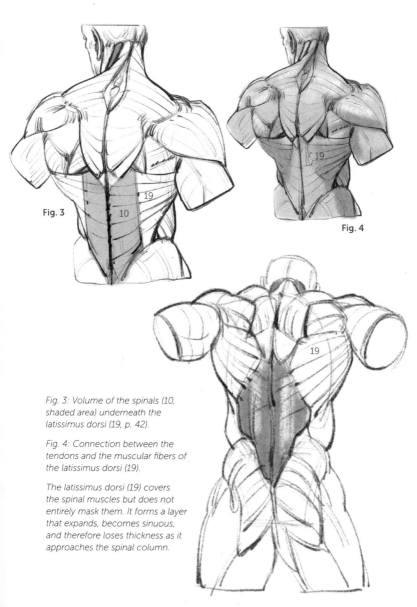

Fig. 3

19

10

Fig. 4

19

19

Fig. 3: Volume of the spinals (10, shaded area) underneath the latissimus dorsi (19, p. 42).

Fig. 4: Connection between the tendons and the muscular fibers of the latissimus dorsi (19).

The latissimus dorsi (19) covers the spinal muscles but does not entirely mask them. It forms a layer that expands, becomes sinuous, and therefore loses thickness as it approaches the spinal column.

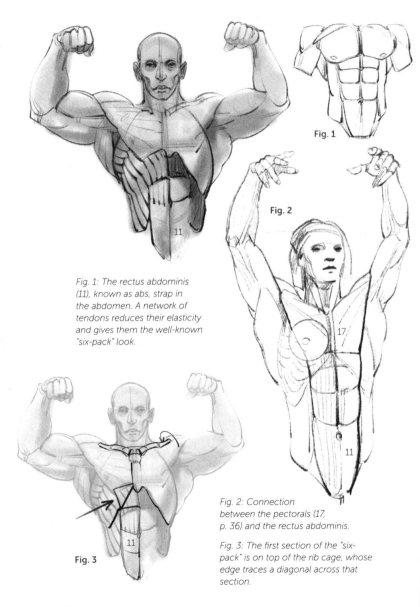

Fig. 1

Fig. 1: The rectus abdominis (11), known as abs, strap in the abdomen. A network of tendons reduces their elasticity and gives them the well-known "six-pack" look.

Fig. 2

Fig. 2: Connection between the pectorals (17, p. 36) and the rectus abdominis.

Fig. 3

Fig. 3: The first section of the "six-pack" is on top of the rib cage, whose edge traces a diagonal across that section.

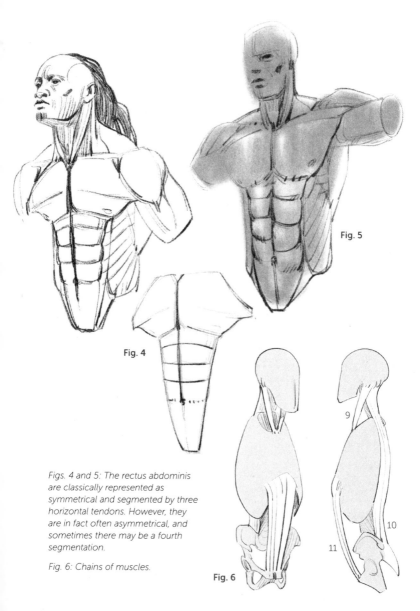

Fig. 4

Fig. 5

Fig. 6

Figs. 4 and 5: The rectus abdominis are classically represented as symmetrical and segmented by three horizontal tendons. However, they are in fact often asymmetrical, and sometimes there may be a fourth segmentation.

Fig. 6: Chains of muscles.

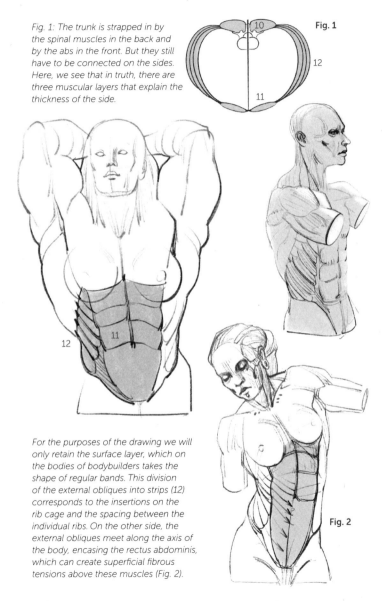

Fig. 1: The trunk is strapped in by the spinal muscles in the back and by the abs in the front. But they still have to be connected on the sides. Here, we see that in truth, there are three muscular layers that explain the thickness of the side.

Fig. 1

For the purposes of the drawing we will only retain the surface layer, which on the bodies of bodybuilders takes the shape of regular bands. This division of the external obliques into strips (12) corresponds to the insertions on the rib cage and the spacing between the individual ribs. On the other side, the external obliques meet along the axis of the body, encasing the rectus abdominis, which can create superficial fibrous tensions above these muscles (Fig. 2).

Fig. 2

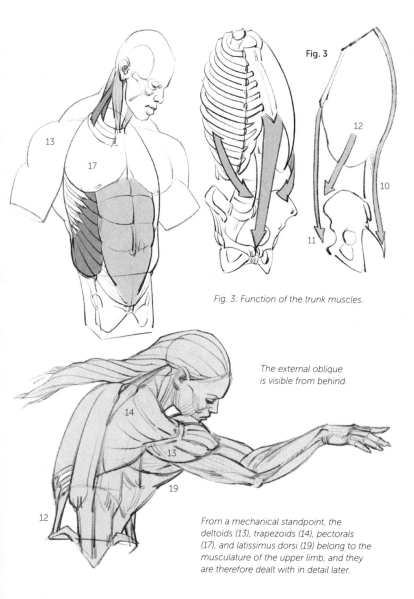

Fig. 3

Fig. 3: Function of the trunk muscles.

The external oblique is visible from behind.

From a mechanical standpoint, the deltoids (13), trapezoids (14), pectorals (17), and latissimus dorsi (19) belong to the musculature of the upper limb, and they are therefore dealt with in detail later.

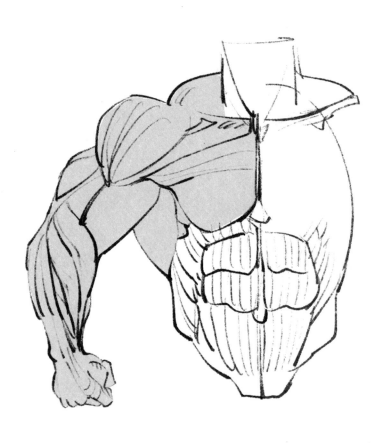

upper limb

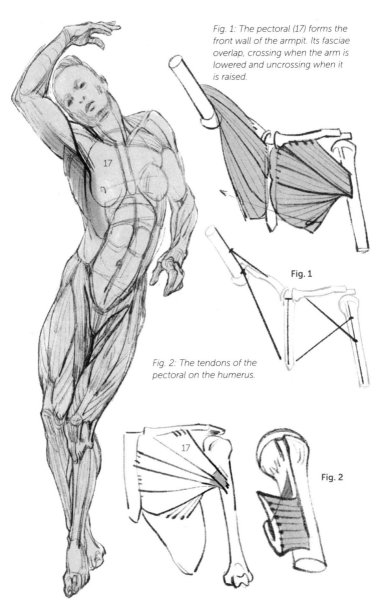

Fig. 1: The pectoral (17) forms the front wall of the armpit. Its fasciae overlap, crossing when the arm is lowered and uncrossing when it is raised.

Fig. 1

Fig. 2: The tendons of the pectoral on the humerus.

Fig. 2

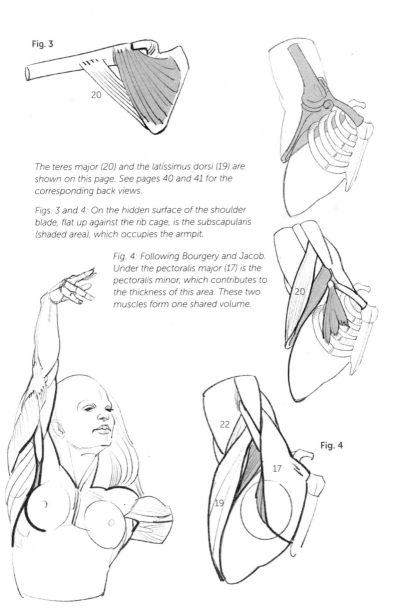

Fig. 3

20

The teres major (20) and the latissimus dorsi (19) are shown on this page. See pages 40 and 41 for the corresponding back views.

Figs. 3 and 4: On the hidden surface of the shoulder blade, flat up against the rib cage, is the subscapularis (shaded area), which occupies the armpit.

Fig. 4: Following Bourgery and Jacob. Under the pectoralis major (17) is the pectoralis minor, which contributes to the thickness of this area. These two muscles form one shared volume.

20

22

Fig. 4

17

19

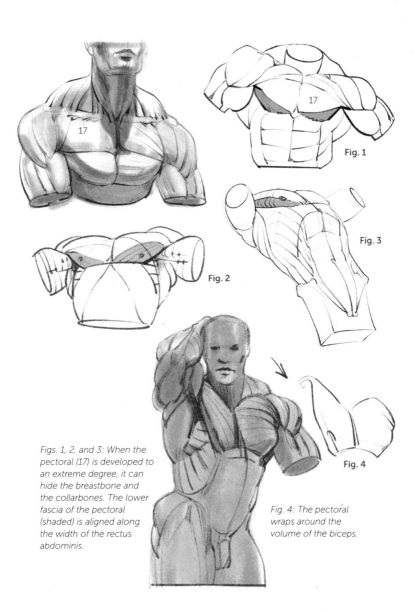

Fig. 1

Fig. 3

Fig. 2

Fig. 4

Figs. 1, 2, and 3: When the pectoral (17) is developed to an extreme degree, it can hide the breastbone and the collarbones. The lower fascia of the pectoral (shaded) is aligned along the width of the rectus abdominis.

Fig. 4: The pectoral wraps around the volume of the biceps.

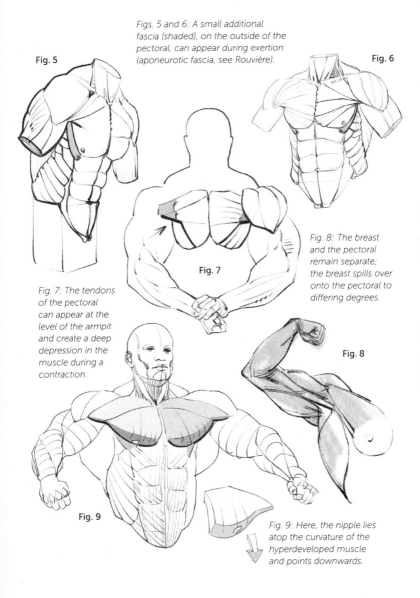

Figs. 5 and 6: A small additional fascia (shaded), on the outside of the pectoral, can appear during exertion (aponeurotic fascia, see Rouvière).

Fig. 5

Fig. 6

Fig. 7

Fig. 7: The tendons of the pectoral can appear at the level of the armpit and create a deep depression in the muscle during a contraction.

Fig. 8: The breast and the pectoral remain separate; the breast spills over onto the pectoral to differing degrees.

Fig. 8

Fig. 9

Fig. 9: Here, the nipple lies atop the curvature of the hyperdeveloped muscle and points downwards.

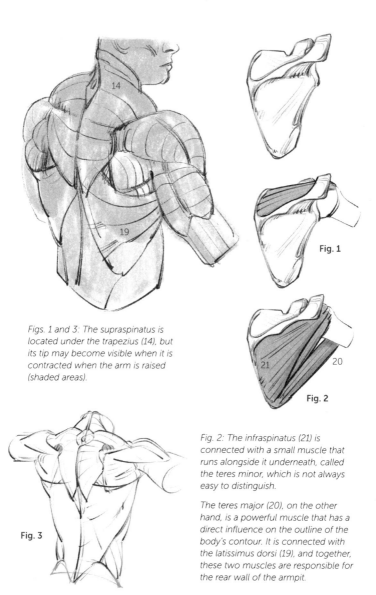

Figs. 1 and 3: The supraspinatus is located under the trapezius (14), but its tip may become visible when it is contracted when the arm is raised (shaded areas).

Fig. 1

Fig. 2

Fig. 3

Fig. 2: The infraspinatus (21) is connected with a small muscle that runs alongside it underneath, called the teres minor, which is not always easy to distinguish.

The teres major (20), on the other hand, is a powerful muscle that has a direct influence on the outline of the body's contour. It is connected with the latissimus dorsi (19), and together, these two muscles are responsible for the rear wall of the armpit.

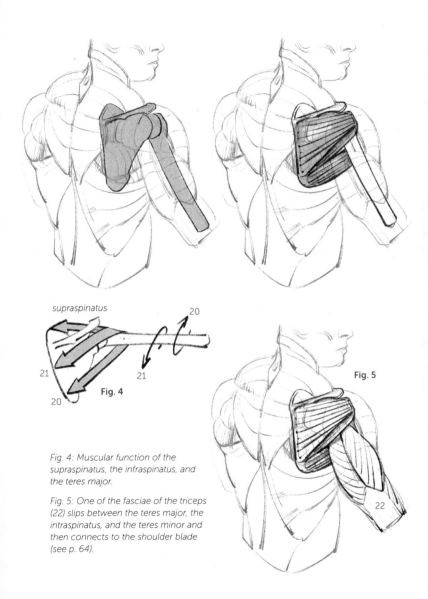

supraspinatus

20

21

21

20

Fig. 4

Fig. 4: Muscular function of the supraspinatus, the infraspinatus, and the teres major.

Fig. 5: One of the fasciae of the triceps (22) slips between the teres major, the intraspinatus, and the teres minor and then connects to the shoulder blade (see p. 64).

(see p. 64)

Fig. 5

22

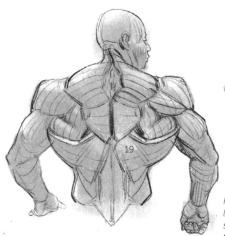

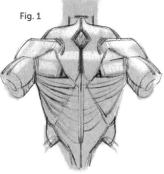

The latissimus dorsi (19) can take on spectacular proportions and completely change the appearance of the torso, giving it a "V" shape that is highly sought after by bodybuilders.

Fig. 1: The contraction of the latissimus dorsi reveals its fan-shaped arrangement and its set of tendons which then, at the level of the kidneys, connect to the spinal muscles (see p. 29).

Fig. 2: Muscular function of the latissimus dorsi (19) and the teres major (20).

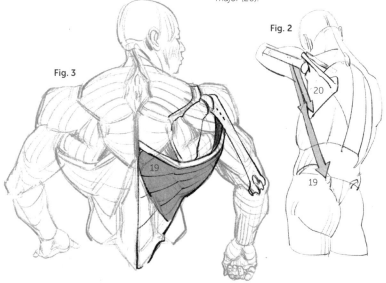

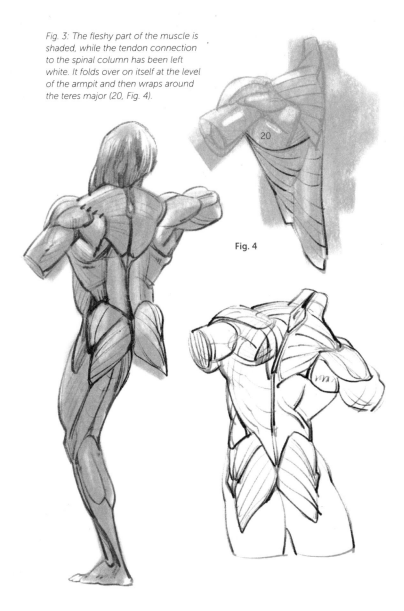

Fig. 3: The fleshy part of the muscle is shaded, while the tendon connection to the spinal column has been left white. It folds over on itself at the level of the armpit and then wraps around the teres major (20, Fig. 4).

Fig. 4

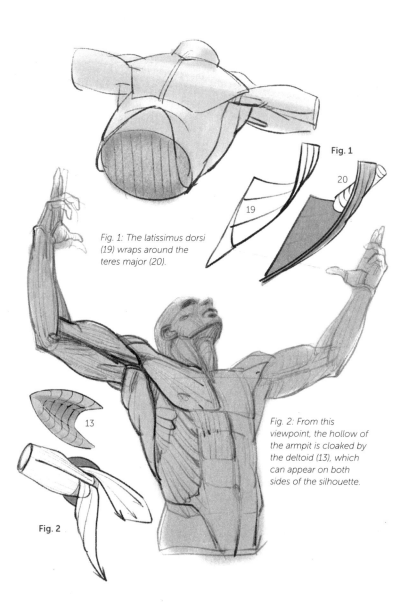

Fig. 1

20

19

Fig. 1: The latissimus dorsi (19) wraps around the teres major (20).

13

Fig. 2: From this viewpoint, the hollow of the armpit is cloaked by the deltoid (13), which can appear on both sides of the silhouette.

Fig. 2

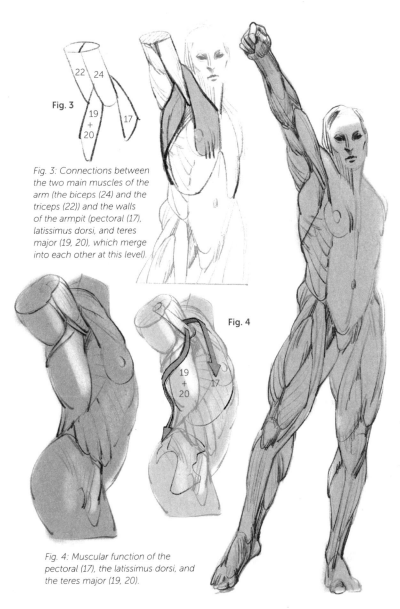

Fig. 3

Fig. 3: Connections between the two main muscles of the arm (the biceps (24) and the triceps (22)) and the walls of the armpit (pectoral (17), latissimus dorsi, and teres major (19, 20), which merge into each other at this level).

Fig. 4

Fig. 4: Muscular function of the pectoral (17), the latissimus dorsi, and the teres major (19, 20).

The upper limbs are suspended from the skull and the spinal column by way of the trapezius (14). When this muscle is developed to its extreme, it very much changes the look of the back of the neck.

Fig. 1: Scapular belt or shoulder girdle (shoulder blades and collarbones).

Fig. 2: The trapezoid (14) is represented here in an improbable position, with the collarbone detached from the sternum and standing up vertically. But this allows us to easily understand its connections with the scapular belt. At the back of the skull, the scapular belt faces the collarbones.

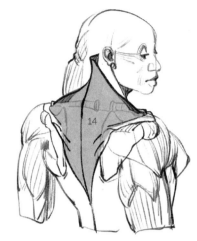

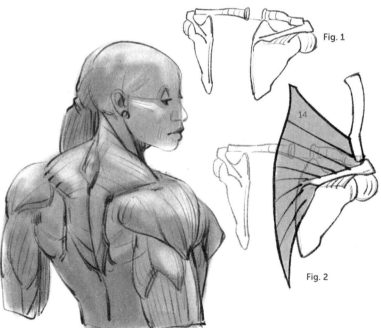

Fig. 1

Fig. 2

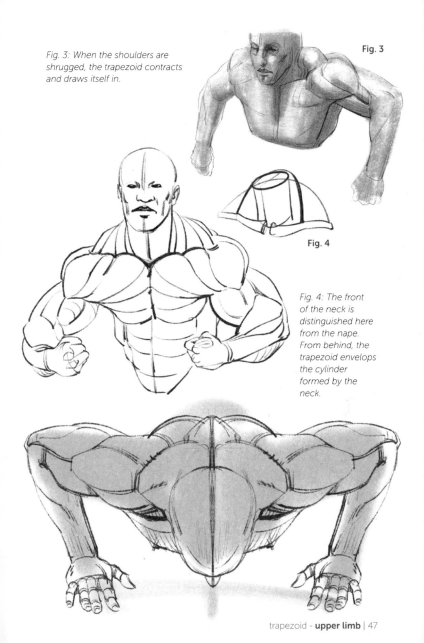

Fig. 3: When the shoulders are shrugged, the trapezoid contracts and draws itself in.

Fig. 3

Fig. 4

Fig. 4: The front of the neck is distinguished here from the nape. From behind, the trapezoid envelops the cylinder formed by the neck.

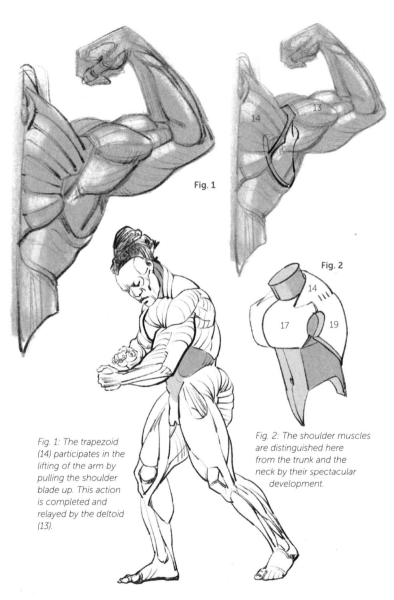

Fig. 1

Fig. 2

Fig. 1: The trapezoid (14) participates in the lifting of the arm by pulling the shoulder blade up. This action is completed and relayed by the deltoid (13).

Fig. 2: The shoulder muscles are distinguished here from the trunk and the neck by their spectacular development.

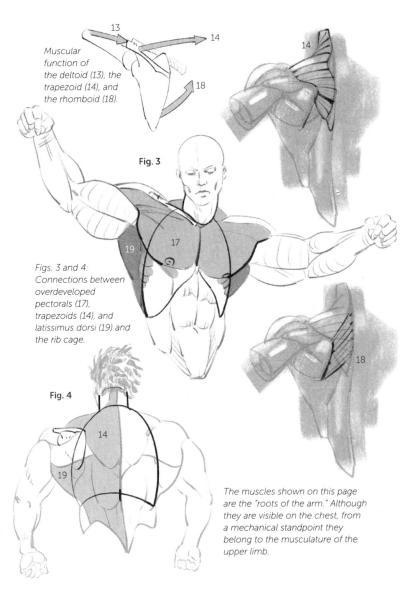

Muscular function of the deltoid (13), the trapezoid (14), and the rhomboid (18).

Fig. 3

Figs. 3 and 4: Connections between overdeveloped pectorals (17), trapezoids (14), and latissimus dorsi (19) and the rib cage.

Fig. 4

The muscles shown on this page are the "roots of the arm." Although they are visible on the chest, from a mechanical standpoint they belong to the musculature of the upper limb.

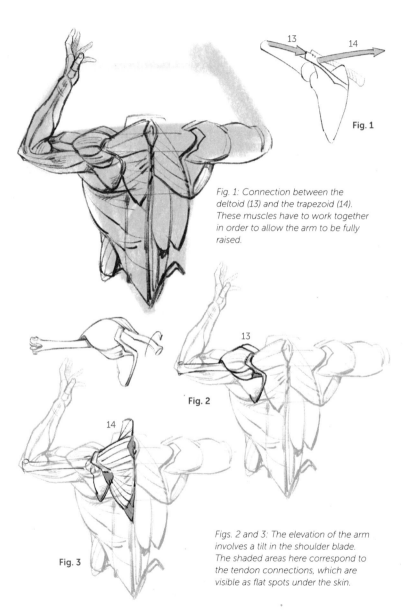

Fig. 1: Connection between the deltoid (13) and the trapezoid (14). These muscles have to work together in order to allow the arm to be fully raised.

Fig. 1

Fig. 2

Figs. 2 and 3: The elevation of the arm involves a tilt in the shoulder blade. The shaded areas here correspond to the tendon connections, which are visible as flat spots under the skin.

Fig. 3

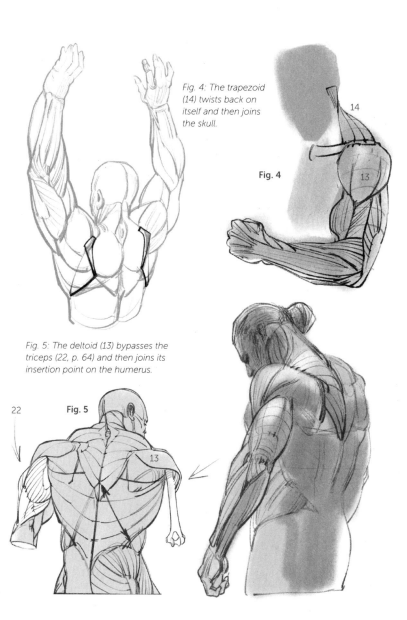

Fig. 4: The trapezoid (14) twists back on itself and then joins the skull.

Fig. 4

14

13

Fig. 5: The deltoid (13) bypasses the triceps (22, p. 64) and then joins its insertion point on the humerus.

22

Fig. 5

13

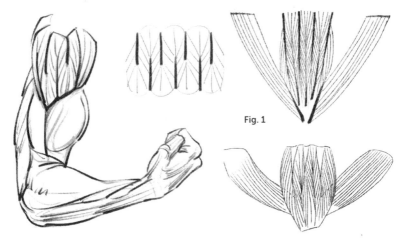

Fig. 1

Fig. 1 (following Paul Richer): The deltoid is divided by many tendon intersections, which reduce the length of its muscle fibers and multiply the number of their connections. This powerful muscle can be seen in all of its complexity during the extended exertions required by bodybuilding.

Fig. 2: The deltoid (13) seems to follow the outline of the pectoral (17) around the shoulder.

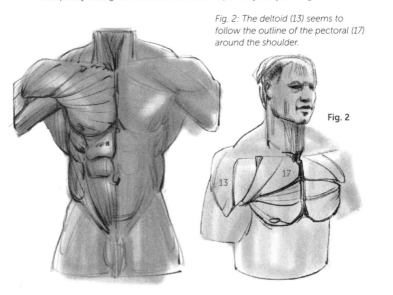

Fig. 2

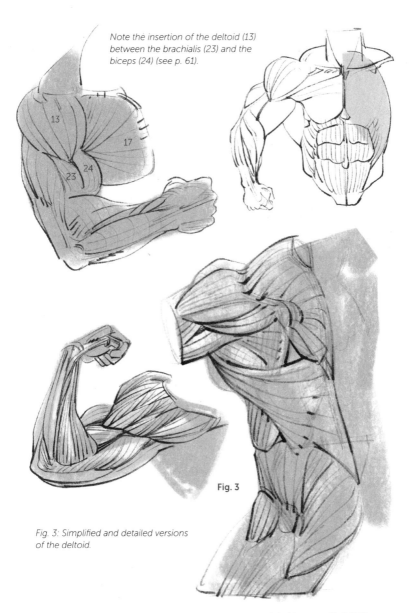

Note the insertion of the deltoid (13) between the brachialis (23) and the biceps (24) *(see p. 61).*

Fig. 3

Fig. 3: Simplified and detailed versions of the deltoid.

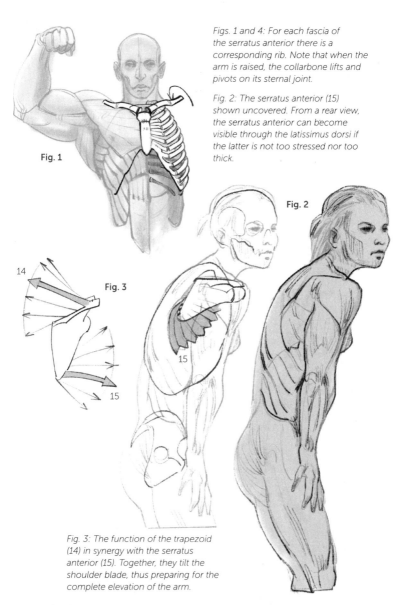

Figs. 1 and 4: For each fascia of the serratus anterior there is a corresponding rib. Note that when the arm is raised, the collarbone lifts and pivots on its sternal joint.

Fig. 2: The serratus anterior (15) shown uncovered. From a rear view, the serratus anterior can become visible through the latissimus dorsi if the latter is not too stressed nor too thick.

Fig. 1

Fig. 2

14

Fig. 3

15

15

Fig. 3: The function of the trapezoid (14) in synergy with the serratus anterior (15). Together, they tilt the shoulder blade, thus preparing for the complete elevation of the arm.

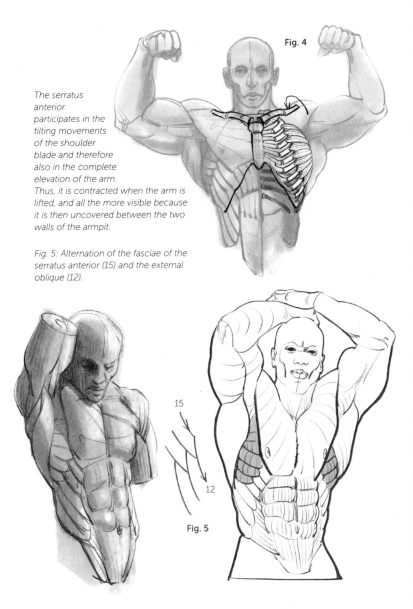

Fig. 4

The serratus anterior participates in the tilting movements of the shoulder blade and therefore also in the complete elevation of the arm.

Thus, it is contracted when the arm is lifted, and all the more visible because it is then uncovered between the two walls of the armpit.

Fig. 5: Alternation of the fasciae of the serratus anterior (15) and the external oblique (12).

15

12

Fig. 5

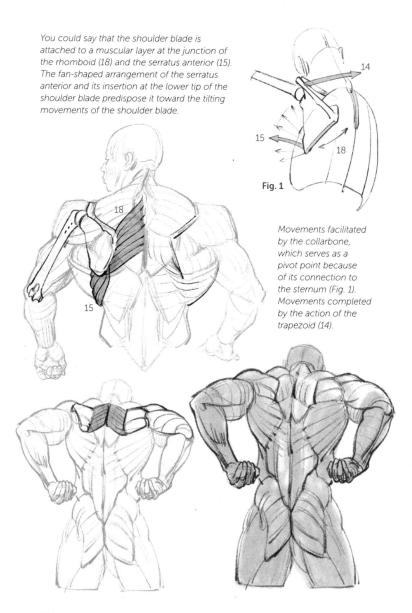

You could say that the shoulder blade is attached to a muscular layer at the junction of the rhomboid (18) and the serratus anterior (15). The fan-shaped arrangement of the serratus anterior and its insertion at the lower tip of the shoulder blade predispose it toward the tilting movements of the shoulder blade.

Fig. 1

Movements facilitated by the collarbone, which serves as a pivot point because of its connection to the sternum (Fig. 1). Movements completed by the action of the trapezoid (14).

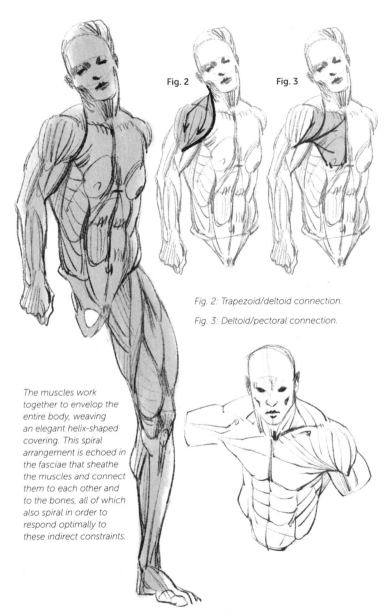

Fig. 2

Fig. 3

Fig. 2: Trapezoid/deltoid connection.

Fig. 3: Deltoid/pectoral connection.

The muscles work together to envelop the entire body, weaving an elegant helix-shaped covering. This spiral arrangement is echoed in the fasciae that sheathe the muscles and connect them to each other and to the bones, all of which also spiral in order to respond optimally to these indirect constraints.

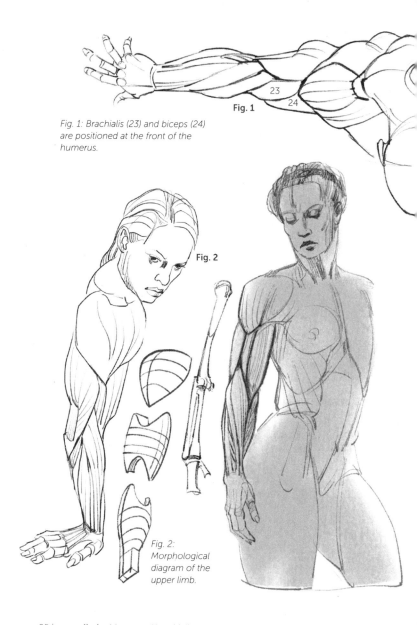

Fig. 1

Fig. 1: Brachialis (23) and biceps (24) are positioned at the front of the humerus.

23
24

Fig. 2

Fig. 2: Morphological diagram of the upper limb.

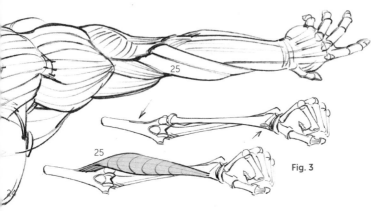

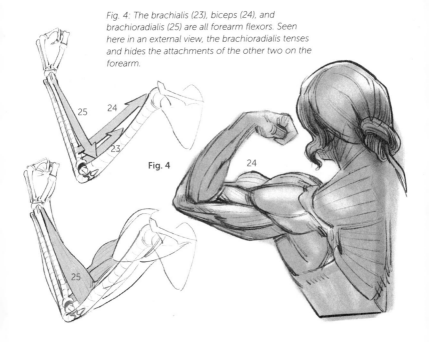

Fig. 3: The brachioradialis (25) of the outside of the elbow reemerges at the wrist, on the side of the thumb. It follows the radius.

Fig. 4: The brachialis (23), biceps (24), and brachioradialis (25) are all forearm flexors. Seen here in an external view, the brachioradialis tenses and hides the attachments of the other two on the forearm.

Fig. 3

Fig. 4

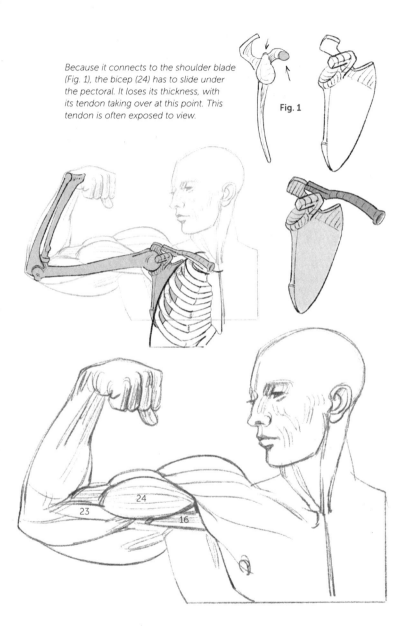

Because it connects to the shoulder blade (Fig. 1), the bicep (24) has to slide under the pectoral. It loses its thickness, with its tendon taking over at this point. This tendon is often exposed to view.

Fig. 1

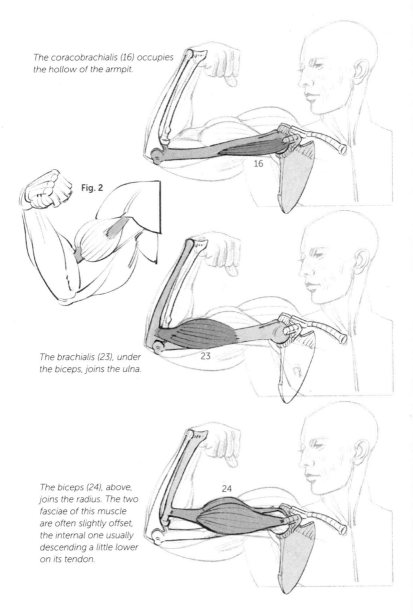

The coracobrachialis (16) occupies the hollow of the armpit.

Fig. 2

16

The brachialis (23), under the biceps, joins the ulna.

23

The biceps (24), above, joins the radius. The two fasciae of this muscle are often slightly offset, the internal one usually descending a little lower on its tendon.

24

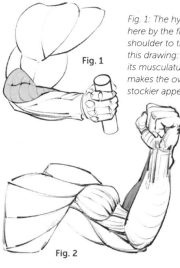

Fig. 1

Fig. 1: The hyperdeveloped brachioradialis is restricted here by the flexion fold. The arm segment (from the shoulder to the elbow) appears extremely short in this drawing: that is because of the development of its musculature as well as that of the shoulder, which makes the overall silhouette broader and gives it a stockier appearance.

Fig. 2: Seen from the inside of the elbow, the brachioradialis (shaded area) passes behind the biceps.

Fig. 3: Detached brachioradialis. It bypasses the biceps and the brachii to attach to the humerus.

Fig. 4: The pronator teres (26) and the brachioradialis (25) are outlined on either side of the biceps. It makes sense that they would have opposite operations in the movements of pronation and supination (rotation of the hand driven by the radius).

Fig. 2

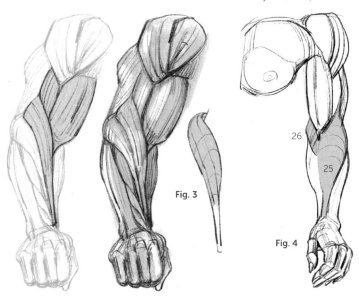

Fig. 3

26

25

Fig. 4

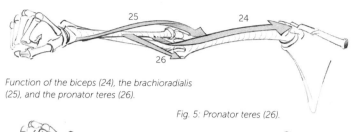

Function of the biceps (24), the brachioradialis (25), and the pronator teres (26).

Fig. 5: Pronator teres (26).

Fig. 5

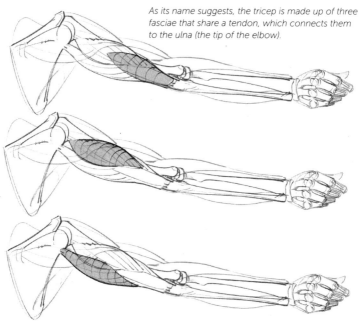

As its name suggests, the tricep is made up of three fasciae that share a tendon, which connects them to the ulna (the tip of the elbow).

Fig. 1: The hyperdevelopment of the tricep makes it possible to see the direction of its fibers.

The arm appears short because of its thickened width.

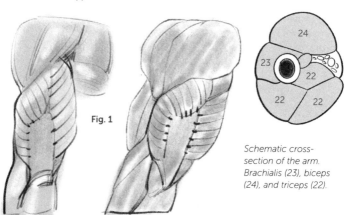

Fig. 1

Schematic cross-section of the arm. Brachialis (23), biceps (24), and triceps (22).

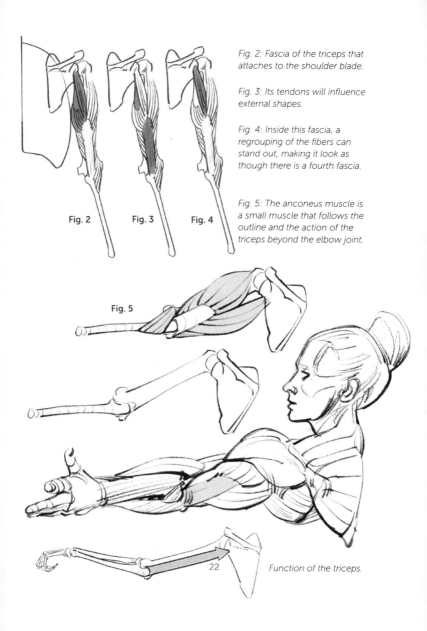

Fig. 2: Fascia of the triceps that attaches to the shoulder blade.

Fig. 3: Its tendons will influence external shapes.

Fig. 4: Inside this fascia, a regrouping of the fibers can stand out, making it look as though there is a fourth fascia.

Fig. 5: The anconeus muscle is a small muscle that follows the outline and the action of the triceps beyond the elbow joint.

Fig. 2 Fig. 3 Fig. 4

Fig. 5

22 Function of the triceps.

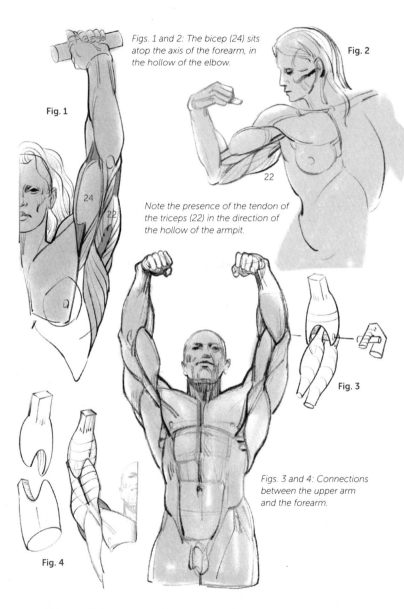

Figs. 1 and 2: The bicep (24) sits atop the axis of the forearm, in the hollow of the elbow.

Fig. 2

Fig. 1

Note the presence of the tendon of the triceps (22) in the direction of the hollow of the armpit.

Fig. 3

Figs. 3 and 4: Connections between the upper arm and the forearm.

Fig. 4

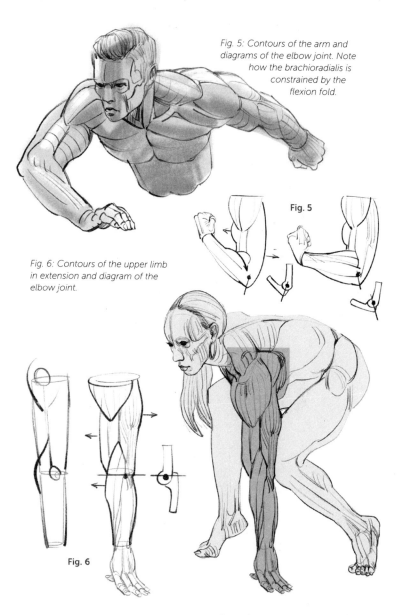

Fig. 5: Contours of the arm and diagrams of the elbow joint. Note how the brachioradialis is constrained by the flexion fold.

Fig. 5

Fig. 6: Contours of the upper limb in extension and diagram of the elbow joint.

Fig. 6

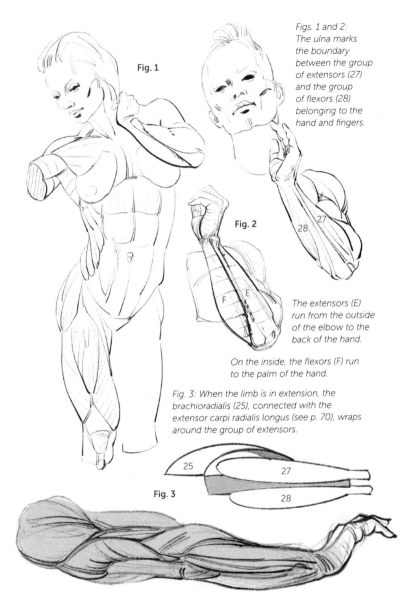

Fig. 1

Figs. 1 and 2: The ulna marks the boundary between the group of extensors (27) and the group of flexors (28) belonging to the hand and fingers.

Fig. 2

28 27

The extensors (E) run from the outside of the elbow to the back of the hand.

On the inside, the flexors (F) run to the palm of the hand.

Fig. 3: When the limb is in extension, the brachioradialis (25), connected with the extensor carpi radialis longus (see p. 70), wraps around the group of extensors.

25 27

Fig. 3 28

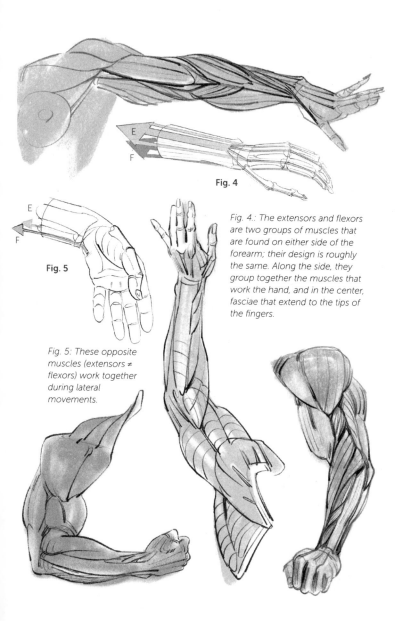

Fig. 4

Fig. 4.: The extensors and flexors are two groups of muscles that are found on either side of the forearm; their design is roughly the same. Along the side, they group together the muscles that work the hand, and in the center, fasciae that extend to the tips of the fingers.

E
F

Fig. 5

Fig. 5: These opposite muscles (extensors ≠ flexors) work together during lateral movements.

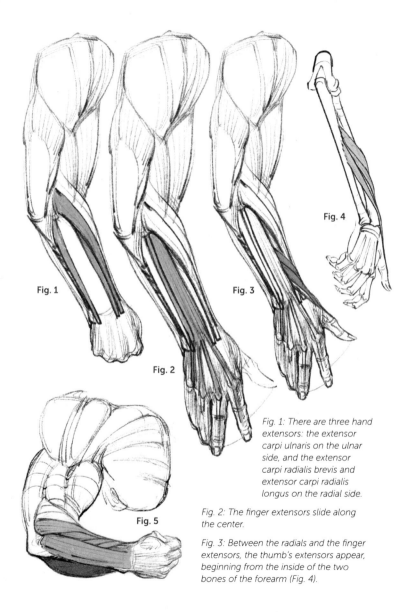

Fig. 1

Fig. 2

Fig. 3

Fig. 4

Fig. 5

Fig. 1: There are three hand extensors: the extensor carpi ulnaris on the ulnar side, and the extensor carpi radialis brevis and extensor carpi radialis longus on the radial side.

Fig. 2: The finger extensors slide along the center.

Fig. 3: Between the radials and the finger extensors, the thumb's extensors appear, beginning from the inside of the two bones of the forearm (Fig. 4).

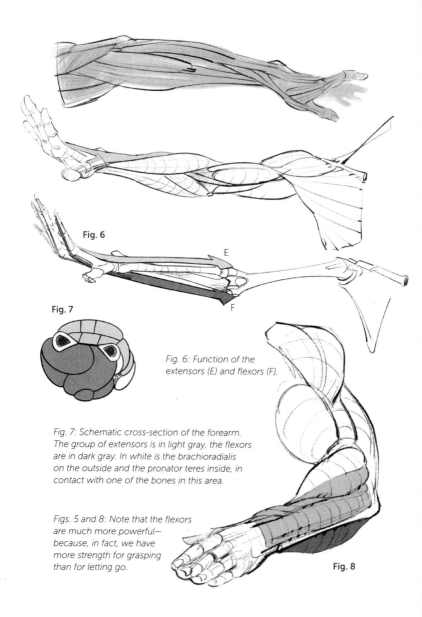

Fig. 6

Fig. 7

E

F

Fig. 6: Function of the extensors (E) and flexors (F).

Fig. 7: Schematic cross-section of the forearm. The group of extensors is in light gray, the flexors are in dark gray. In white is the brachioradialis on the outside and the pronator teres inside, in contact with one of the bones in this area.

Figs. 5 and 8: Note that the flexors are much more powerful— because, in fact, we have more strength for grasping than for letting go.

Fig. 8

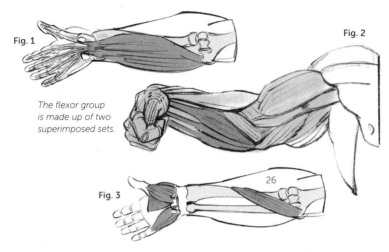

Fig. 1

Fig. 2

The flexor group is made up of two superimposed sets.

Fig. 3

26

The finger flexors (Fig. 1, deeper layer) are covered by the hand flexors (Fig. 2, outer layer), which take the shape of powerful tendons. From top to bottom, these are: the flexor carpi radialis, the palmaris longus (it is in the center and connects to the fibrous tissue in the palm; according to Paul Richer, it is missing in about 1 in 8 people), and the flexor carpi ulnaris.

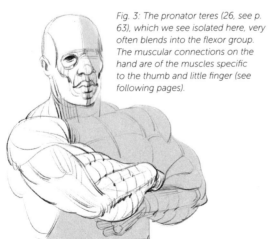

Fig. 3: The pronator teres (26, see p. 63), which we see isolated here, very often blends into the flexor group. The muscular connections on the hand are of the muscles specific to the thumb and little finger (see following pages).

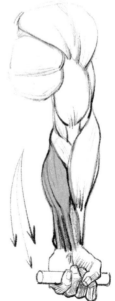

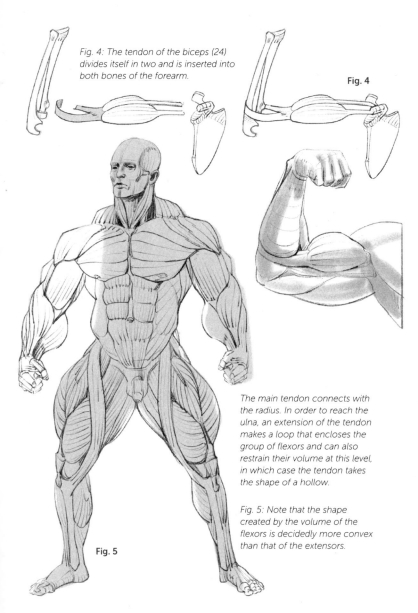

Fig. 4: The tendon of the biceps (24) divides itself in two and is inserted into both bones of the forearm.

Fig. 4

The main tendon connects with the radius. In order to reach the ulna, an extension of the tendon makes a loop that encloses the group of flexors and can also restrain their volume at this level, in which case the tendon takes the shape of a hollow.

Fig. 5: Note that the shape created by the volume of the flexors is decidedly more convex than that of the extensors.

Fig. 5

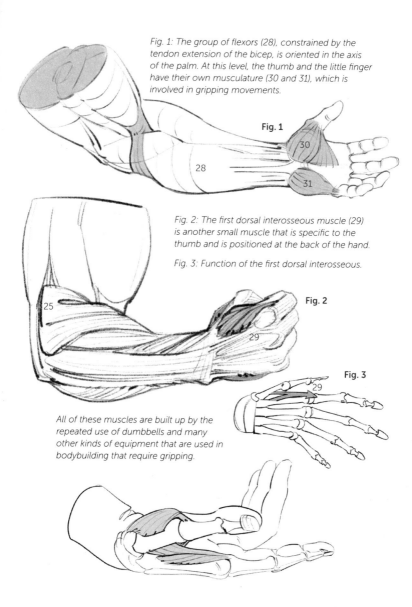

Fig. 1: The group of flexors (28), constrained by the tendon extension of the bicep, is oriented in the axis of the palm. At this level, the thumb and the little finger have their own musculature (30 and 31), which is involved in gripping movements.

Fig. 1

Fig. 2: The first dorsal interosseous muscle (29) is another small muscle that is specific to the thumb and is positioned at the back of the hand.

Fig. 3: Function of the first dorsal interosseous.

Fig. 2

Fig. 3

All of these muscles are built up by the repeated use of dumbbells and many other kinds of equipment that are used in bodybuilding that require gripping.

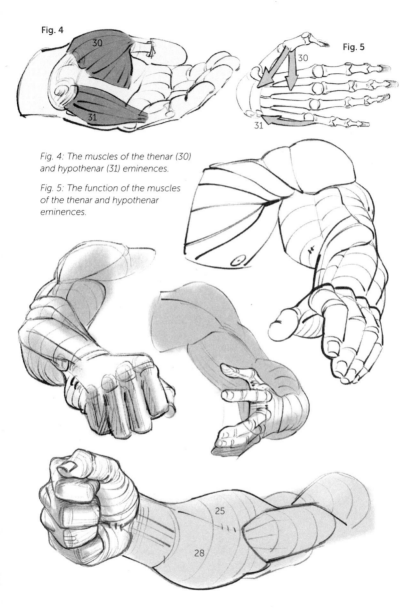

Fig. 4

30

31

Fig. 5

30

31

Fig. 4: The muscles of the thenar (30) and hypothenar (31) eminences.

Fig. 5: The function of the muscles of the thenar and hypothenar eminences.

25

28

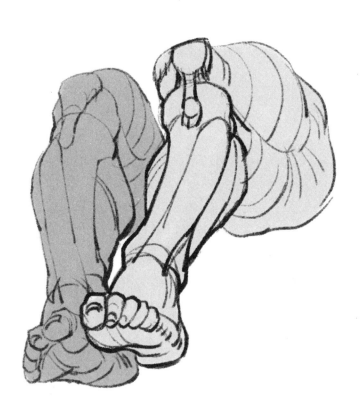

lower limb

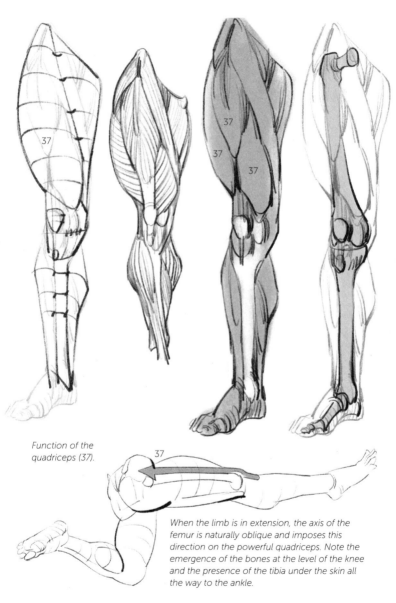

Function of the quadriceps (37).

37

When the limb is in extension, the axis of the femur is naturally oblique and imposes this direction on the powerful quadriceps. Note the emergence of the bones at the level of the knee and the presence of the tibia under the skin all the way to the ankle.

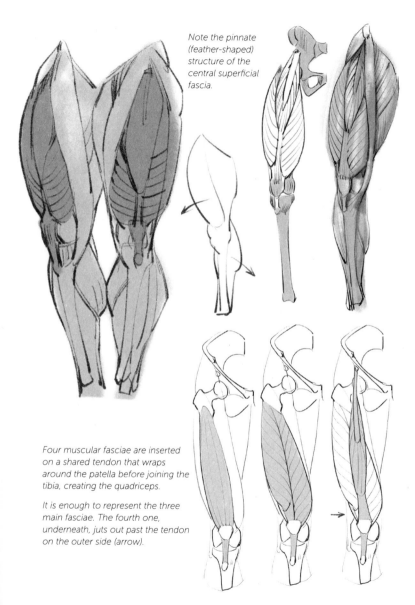

Note the pinnate (feather-shaped) structure of the central superficial fascia.

Four muscular fasciae are inserted on a shared tendon that wraps around the patella before joining the tibia, creating the quadriceps.

It is enough to represent the three main fasciae. The fourth one, underneath, juts out past the tendon on the outer side (arrow).

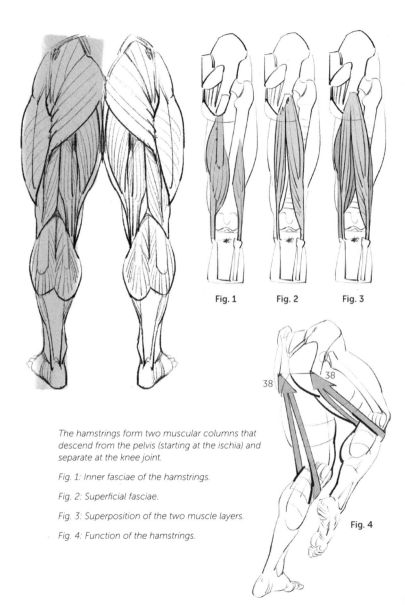

Fig. 1 Fig. 2 Fig. 3

The hamstrings form two muscular columns that descend from the pelvis (starting at the ischia) and separate at the knee joint.

Fig. 1: Inner fasciae of the hamstrings.

Fig. 2: Superficial fasciae.

Fig. 3: Superposition of the two muscle layers.

Fig. 4: Function of the hamstrings.

Fig. 4

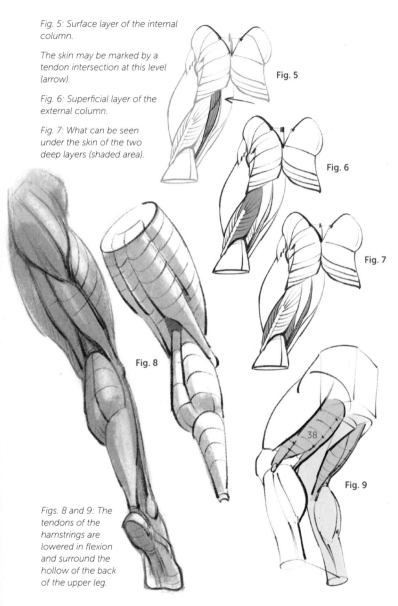

Fig. 5: Surface layer of the internal column.

The skin may be marked by a tendon intersection at this level (arrow).

Fig. 6: Superficial layer of the external column.

Fig. 7: What can be seen under the skin of the two deep layers (shaded area).

Fig. 5

Fig. 6

Fig. 7

Fig. 8

Fig. 9

Figs. 8 and 9: The tendons of the hamstrings are lowered in flexion and surround the hollow of the back of the upper leg.

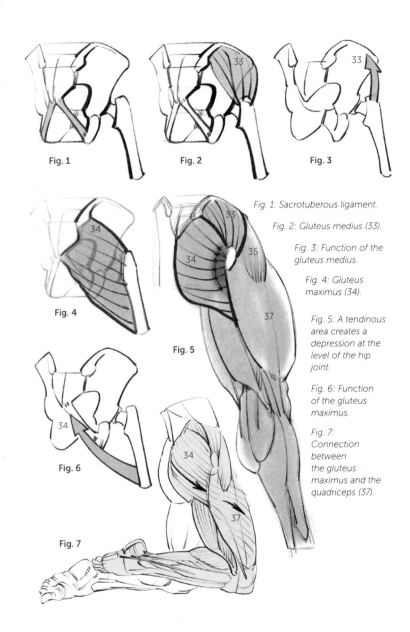

Fig. 1: Sacrotuberous ligament.

Fig. 2: Gluteus medius (33).

Fig. 3: Function of the gluteus medius.

Fig. 4: Gluteus maximus (34).

Fig. 5: A tendinous area creates a depression at the level of the hip joint.

Fig. 6: Function of the gluteus maximus.

Fig. 7: Connection between the gluteus maximus and the quadriceps (37).

Fig. 1

Fig. 2

Fig. 3

Fig. 4

Fig. 5

Fig. 6

Fig. 7

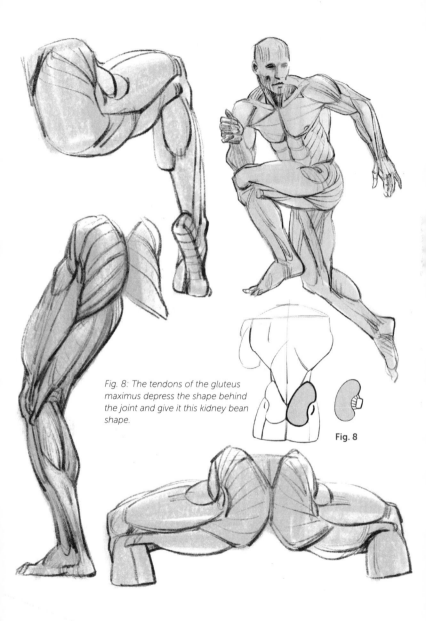

Fig. 8: The tendons of the gluteus maximus depress the shape behind the joint and give it this kidney bean shape.

Fig. 8

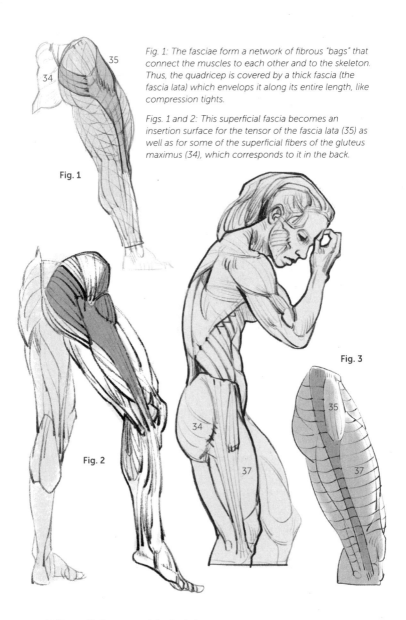

Fig. 1: The fasciae form a network of fibrous "bags" that connect the muscles to each other and to the skeleton. Thus, the quadricep is covered by a thick fascia (the fascia lata) which envelops it along its entire length, like compression tights.

Figs. 1 and 2: This superficial fascia becomes an insertion surface for the tensor of the fascia lata (35) as well as for some of the superficial fibers of the gluteus maximus (34), which corresponds to it in the back.

Fig. 1

Fig. 2

Fig. 3

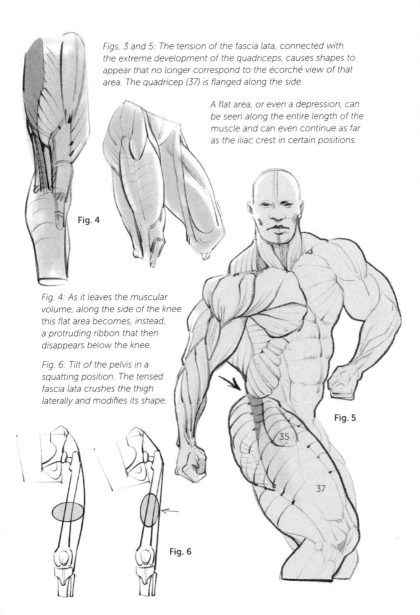

Figs. 3 and 5: The tension of the fascia lata, connected with the extreme development of the quadriceps, causes shapes to appear that no longer correspond to the écorché view of that area. The quadricep (37) is flanged along the side.

A flat area, or even a depression, can be seen along the entire length of the muscle and can even continue as far as the iliac crest in certain positions.

Fig. 4

Fig. 4: As it leaves the muscular volume, along the side of the knee this flat area becomes, instead, a protruding ribbon that then disappears below the knee.

Fig. 6: Tilt of the pelvis in a squatting position. The tensed fascia lata crushes the thigh laterally and modifies its shape.

Fig. 5

35

37

Fig. 6

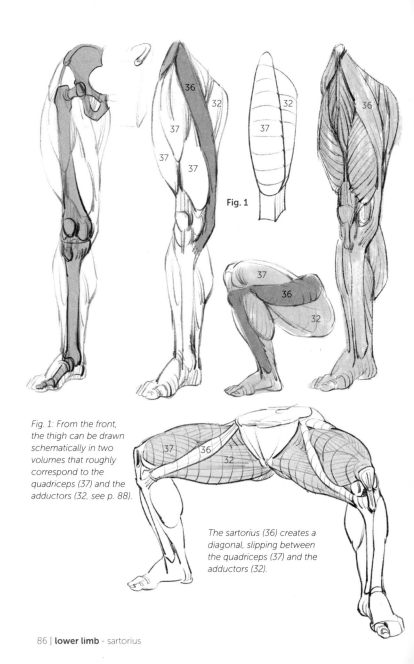

Fig. 1

Fig. 1: From the front, the thigh can be drawn schematically in two volumes that roughly correspond to the quadriceps (37) and the adductors (32, see p. 88).

The sartorius (36) creates a diagonal, slipping between the quadriceps (37) and the adductors (32).

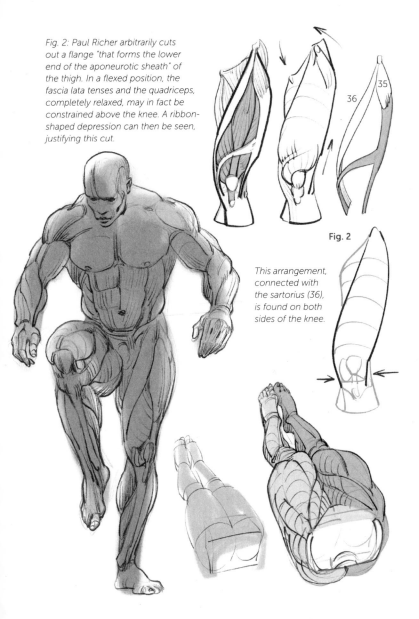

Fig. 2: Paul Richer arbitrarily cuts out a flange "that forms the lower end of the aponeurotic sheath" of the thigh. In a flexed position, the fascia lata tenses and the quadriceps, completely relaxed, may in fact be constrained above the knee. A ribbon-shaped depression can then be seen, justifying this cut.

35

36

Fig. 2

This arrangement, connected with the sartorius (36), is found on both sides of the knee.

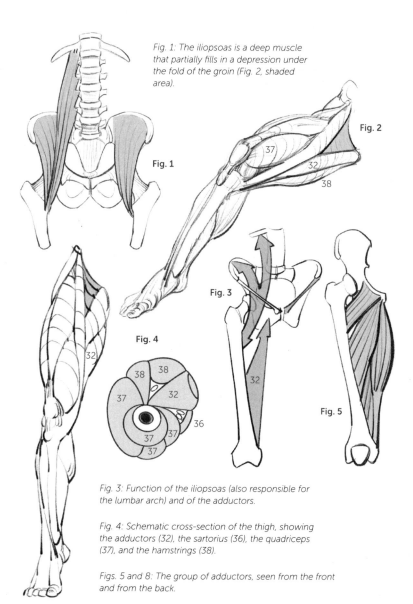

Fig. 1: The iliopsoas is a deep muscle that partially fills in a depression under the fold of the groin (Fig. 2, shaded area).

Fig. 1

Fig. 2

37
32
38

Fig. 3

32

Fig. 4

32

38 38
37 32
37 37 36
37

Fig. 5

Fig. 3: Function of the iliopsoas (also responsible for the lumbar arch) and of the adductors.

Fig. 4: Schematic cross-section of the thigh, showing the adductors (32), the sartorius (36), the quadriceps (37), and the hamstrings (38).

Figs. 5 and 8: The group of adductors, seen from the front and from the back.

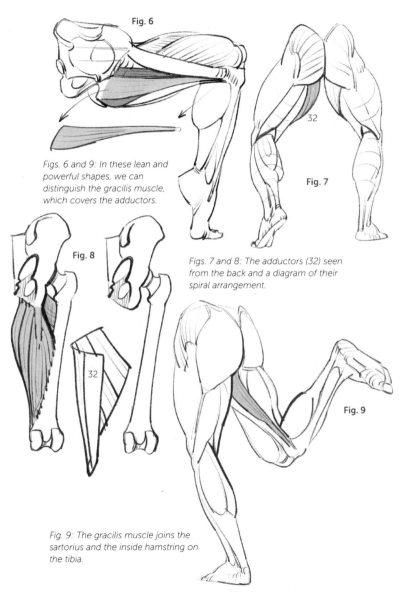

Fig. 6

Figs. 6 and 9: In these lean and powerful shapes, we can distinguish the gracilis muscle, which covers the adductors.

Fig. 7

32

Fig. 8

32

Figs. 7 and 8: The adductors (32) seen from the back and a diagram of their spiral arrangement.

Fig. 9

Fig. 9: The gracilis muscle joins the sartorius and the inside hamstring on the tibia.

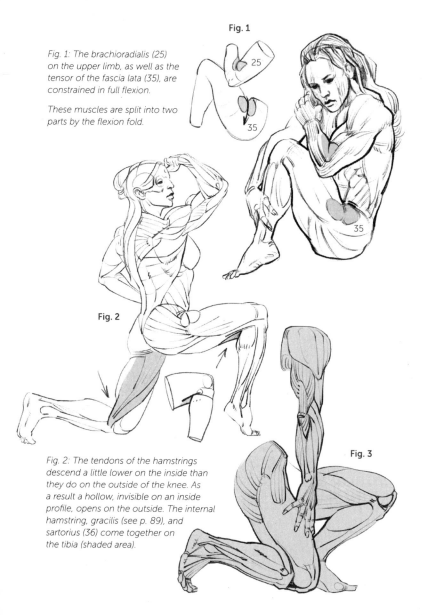

Fig. 1

Fig. 1: The brachioradialis (25) on the upper limb, as well as the tensor of the fascia lata (35), are constrained in full flexion.

These muscles are split into two parts by the flexion fold.

25

35

35

Fig. 2

Fig. 2: The tendons of the hamstrings descend a little lower on the inside than they do on the outside of the knee. As a result a hollow, invisible on an inside profile, opens on the outside. The internal hamstring, gracilis (see p. 89), and sartorius (36) come together on the tibia (shaded area).

Fig. 3

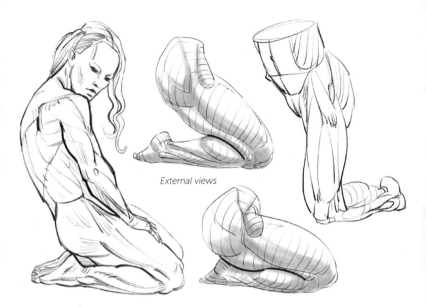

External views

Figs. 3 and 4: On the outside of the thigh, in full flexion, the calf imposes its contour, whereas on the inside, by contrast, the muscles of the thigh prevail (where the hamstrings, gracilis, and sartorius come together).

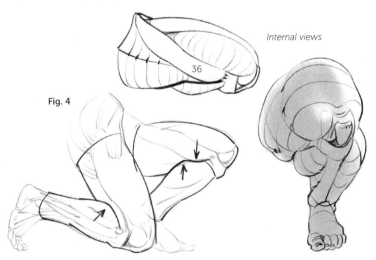

Internal views

Fig. 4

36

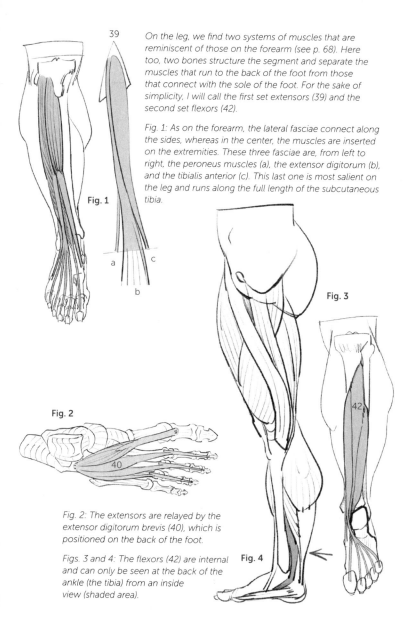

39

On the leg, we find two systems of muscles that are reminiscent of those on the forearm (see p. 68). Here too, two bones structure the segment and separate the muscles that run to the back of the foot from those that connect with the sole of the foot. For the sake of simplicity, I will call the first set extensors (39) and the second set flexors (42).

Fig. 1: As on the forearm, the lateral fasciae connect along the sides, whereas in the center, the muscles are inserted on the extremities. These three fasciae are, from left to right, the peroneus muscles (a), the extensor digitorum (b), and the tibialis anterior (c). This last one is most salient on the leg and runs along the full length of the subcutaneous tibia.

Fig. 1

a c

b

Fig. 3

42

Fig. 2

40

Fig. 2: The extensors are relayed by the extensor digitorum brevis (40), which is positioned on the back of the foot.

Figs. 3 and 4: The flexors (42) are internal and can only be seen at the back of the ankle (the tibia) from an inside view (shaded area).

Fig. 4

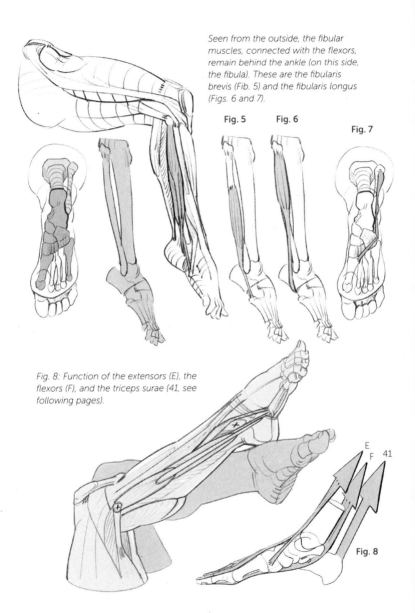

Seen from the outside, the fibular muscles, connected with the flexors, remain behind the ankle (on this side, the fibula). These are the fibularis brevis (Fib. 5) and the fibularis longus (Figs. 6 and 7).

Fig. 5 **Fig. 6**

Fig. 7

Fig. 8: Function of the extensors (E), the flexors (F), and the triceps surae (41, see following pages).

E
F 41

Fig. 8

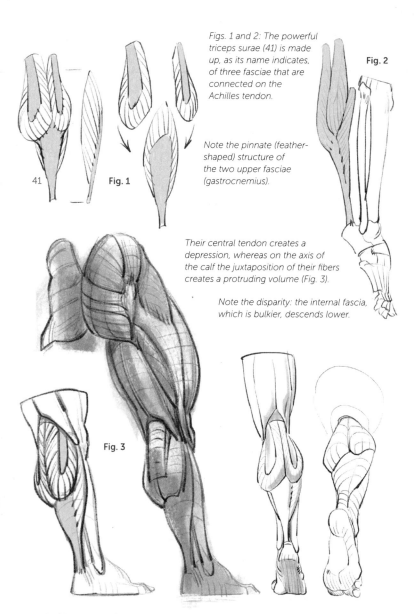

Figs. 1 and 2: The powerful triceps surae (41) is made up, as its name indicates, of three fasciae that are connected on the Achilles tendon.

Fig. 2

Note the pinnate (feather-shaped) structure of the two upper fasciae (gastrocnemius).

41 **Fig. 1**

Their central tendon creates a depression, whereas on the axis of the calf the juxtaposition of their fibers creates a protruding volume (Fig. 3).

Note the disparity: the internal fascia, which is bulkier, descends lower.

Fig. 3

Fig. 4: On the foot, we have already seen the extensor digitorum brevis (p. 92); we still have to position the abductor hallucis (the abductor of the big toe) (45), which tenses the arch of the foot. The fat under the skin of the foot masks almost all of the other muscles.

Fig. 5: Schematic cross-section of the leg. The extensors (39), flexors (42), and triceps (41).

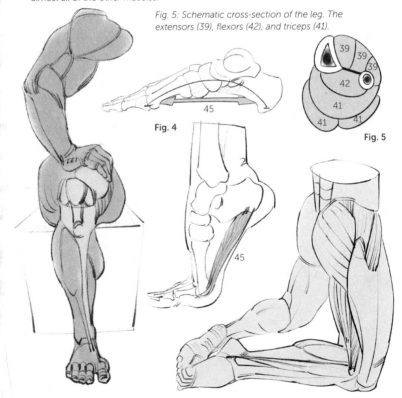

Fig. 4

Fig. 5

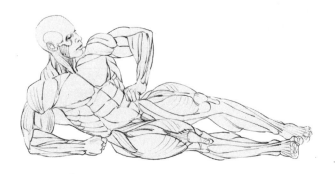

resources

This little book certainly owes a great deal to the many comic book artists, and in particular to the work of John Buscema.

Bouchet, Alain, and Jacques Cuilleret, *Anatomie topographique et fonctionnelle*, Simep, 1983.

Bourgery, Jean-Marc, and Nicolas-Henri Jacob, *Atlas d'anatomie humaine et de chirurgie*, Taschen, 2015.

Butler, George, and Robert Fiore, *Pumping Iron*, documentary, 1977.

Crews, Harry, *Body*, novel, Folio, 2017.

Delavier, Frédéric, *Guide des mouvements de musculation*, Vigot, 2010.

Giraldi, William, *Le Corps du héros*, Globe, 2018 [original title *The Hero's Body: A Memoir*].

Richer, Paul, *Nouvelle anatomie artistique – Attitudes et mouvements*, Plon, 1921 (available on Gallica).

Richer, Paul, *Traité d'anatomie artistique*, Bibliothèque de l'image, 1996.

Rouvière, Henri, and André Delmas, *Anatomie humaine*, Masson, 1984.

Schoenfeld, Brad, *Hypertrophie. Approche pratique et scientifique du développement musculaire*, 4 Trainer, 2019.

The Visible Human Project: photographs of sections of the human body.

Yudin, Vlad, *Generation Iron*, documentary series, 2013.
https://www.imaios.com